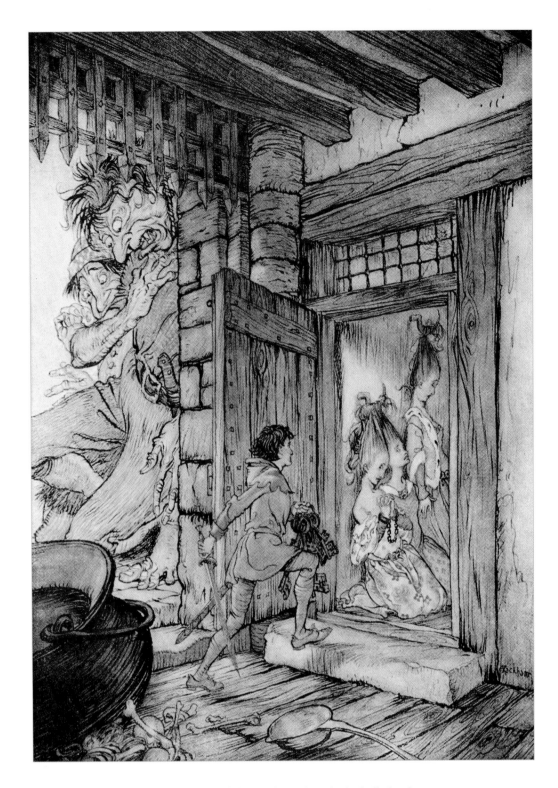

Taking the keys of the castle, Jack unlocked all the doors
From "Jack the Giant-Killer"

Rackham's Fairy Tale Illustrations
in Full Color

SELECTED AND EDITED BY
JEFF A. MENGES

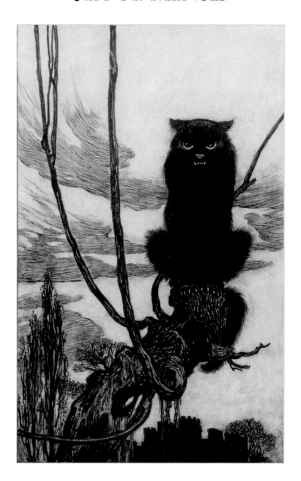

Dover Publications, Inc.
Mineola, New York

Bibliographical Note

This Dover edition, first published in 2002, is an original compilation of illustrations from the following works: *The Allies' Fairy Book* (published by J.B. Lippincott Co., Philadelphia, and William Heinemann, London, n.d.); *Little Brother & Little Sister and Other Tales by the Brothers Grimm* (published by Dodd, Mead & Company, New York, n.d.); *English Fairy Tales* (published by the Macmillan Company, New York, in 1922); *Snowdrop and Other Tales by the Brothers Grimm* (published by Doubleday, Page & Company, Garden City, New York, in 1923); *Irish Fairy Tales* (published by the Macmillan Company, New York, in 1920); and *Hansel & Grethel and Other Tales by the Brothers Grimm* (published by Constable & Co., Ltd., London, n.d.).

Library of Congress Cataloging-in-Publication Data

Rackham, Arthur, 1867–1939.
 Rackham's fairy tale illustrations / selected and with an introduction by Jeff A. Menges.— Dover ed.
 p. cm.
 ISBN-13: 978-0-486-42167-4 (pbk.)
 ISBN-10: 0-486-42167-8 (pbk.)
 1. Rackham, Arthur, 1867–1939—Themes, motives. 2. Fairy tales—Illustrations. I. Title: Fairy tale illustrations. II. Menges, Jeff A. III. Title.

NC978.5.R32 A4 2002
741.6'4'092—dc21

2001058414

Manufactured in the United States by Courier Corporation
42167806
www.doverpublications.com

INTRODUCTION

Arthur Rackham was born in London in 1867. Although he would later advise budding artists to search out more lucrative fields, Rackham himself began sketching as a child and attended the Lambeth School of Art. After briefly working in the insurance business, he pursued a career as an illustrator, depicting various topics for magazines, and then embraced the challenges of book illustration. His first illustrations of Grimm's fairy tales appeared in 1900, a golden age in publishing. Tremendous growth in industry had made book manufacturing more affordable; color plates were being produced using early forms of separated lithography, and readers hungered for color images. Rackham was then 33 years of age, enjoying the successes of *The Ingoldsby Legends* (1898; revised 1907) and *Gulliver's Travels* (1909).

Every great age has those who make it so. Rackham's strength was in his rich imagination, sensitive line work, and restrained use of color, all of which combined to form a style that defined children's literature illustrations in a manner unmatched by any other artist of the period. Rackham led the field for the four decades following the turn of the century; his work is still full of wonder, originality, and inspiration for today's reader.

Creatures of fantasy, legend, and fairy tales represented the core of Rackham's output. His imaginative interpretations of witches, elves, giants, and fairies have influenced many of the images that have been produced ever since. His incorporation of a natural environment where animals and trees often take on a depth of personality produces pictures rich in warmth and emotion. Rackham's images support and enhance the story, giving the reader a window to a fantastic world. For this far-reaching and enduring imagery, he has been dubbed the "Beloved Enchanter." Following his death in 1939, his body of work has remained much appreciated, his influence long-lasting.

No subject matter represents Rackham's work better than fairy tales. After his initial interpretation of Grimm's tales in 1900 [revised 1909], he went on to expand upon that collection with *Little Brother and Little Sister* (1917) and *Snowdrop and Other Tales* (1920) and *Hansel and Grethel and Other Tales* (1920). These three volumes contain more than 100 ink pieces and 50 color images. Other fairy tale work from the same strong period in Rackham's career comes from more international sources. *The Allies' Fairy Book* (1916) contains tales from 11 different nations—all allied forces during World War I. Closer to his own roots was *English Fairy Tales* (1918) and *Irish Fairy Tales* (1920). The imagery in the present collection has been selected from these sources—brought together for their imagination, craftsmanship, and magic.

With deep appreciation and respect,

Jeff A. Menges
November 2001

This book is dedicated to my wife, Lynne;
without her support,
all my creative endeavors would fall shorter.

JM

LIST OF PLATES

THE PLATES

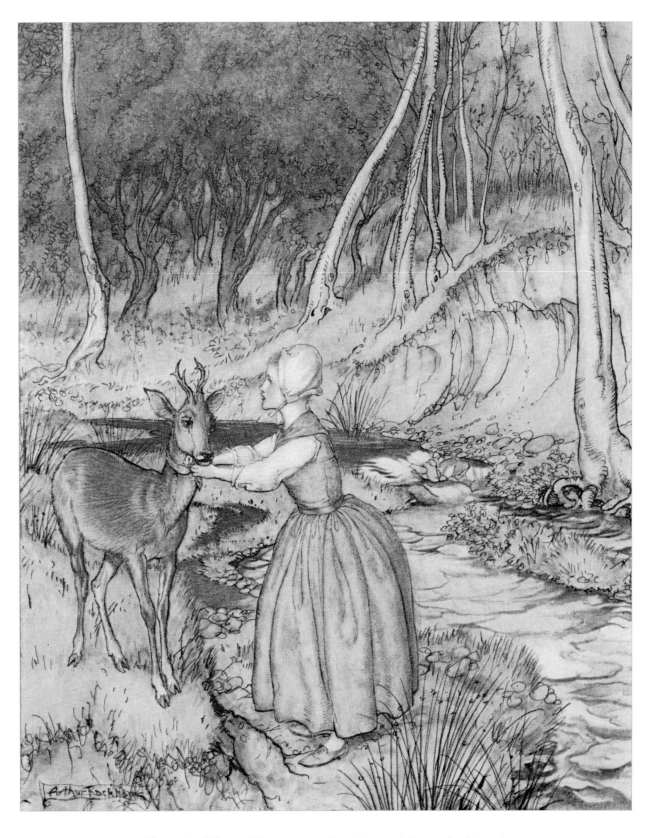

She took off her golden garter and put it round the roe-buck's neck
From "Little Brother and Little Sister"

PLATE 1

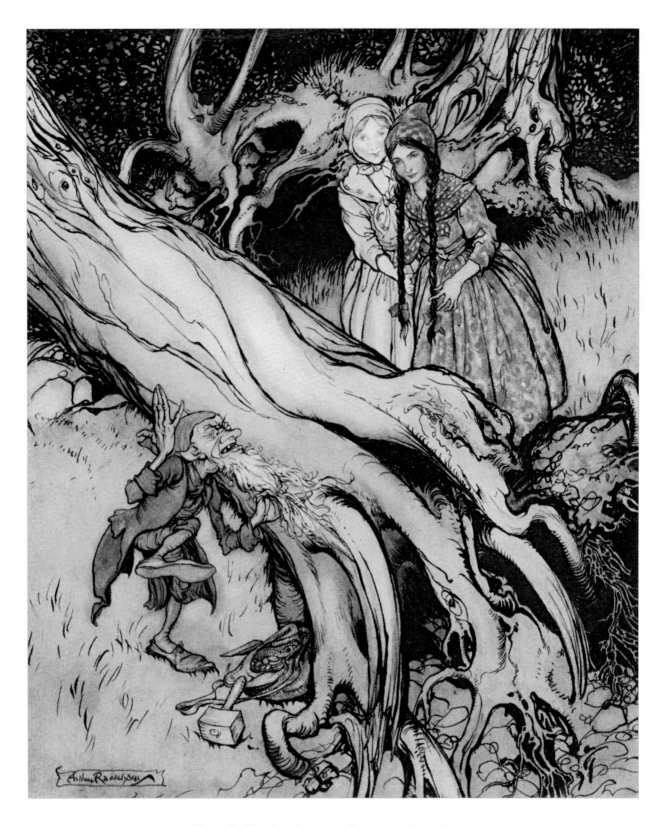

The end of his beard was caught in a crack in the tree
From "Snow-White and Rose-Red"

PLATE 2

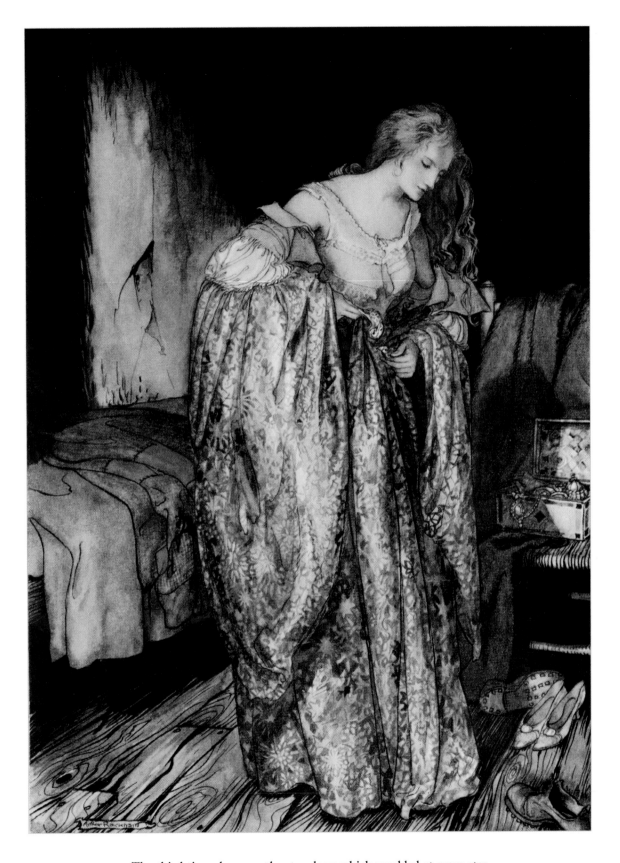

The third time she wore the star-dress which sparkled at every step
From "The True Sweetheart"

PLATE 3

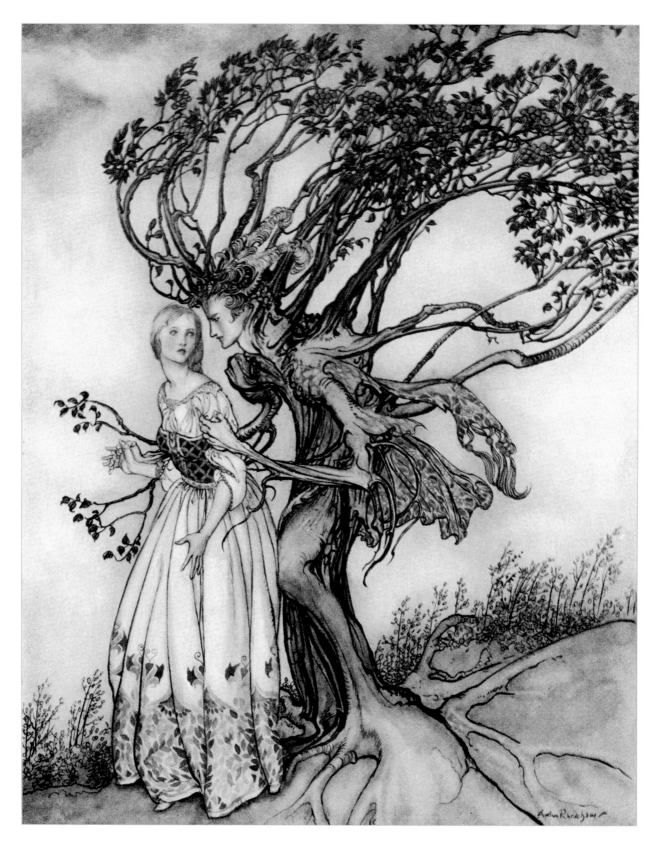

Suddenly the branches twined round her and turned into two arms
From "The Old Woman in the Wood"

PLATE 4

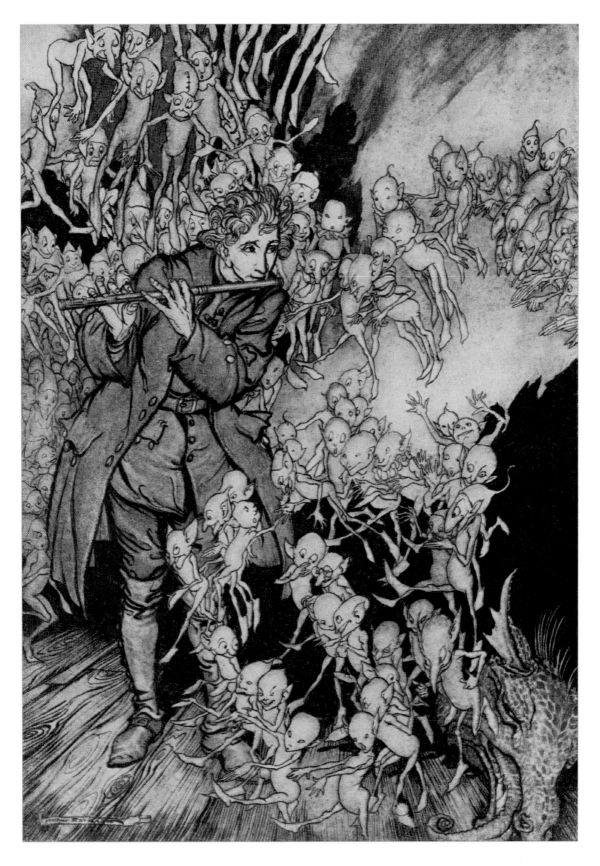

He played until the room was entirely filled with gnomes
From "The Gnomes"

PLATE 5

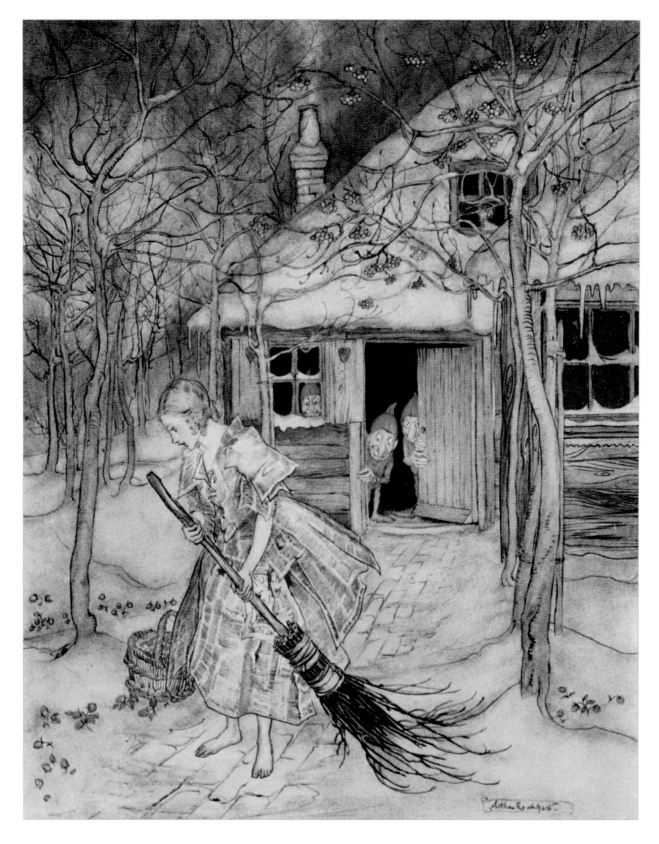

What did she find there but real ripe strawberries
From "The Three Little Men in the Wood"

PLATE 6

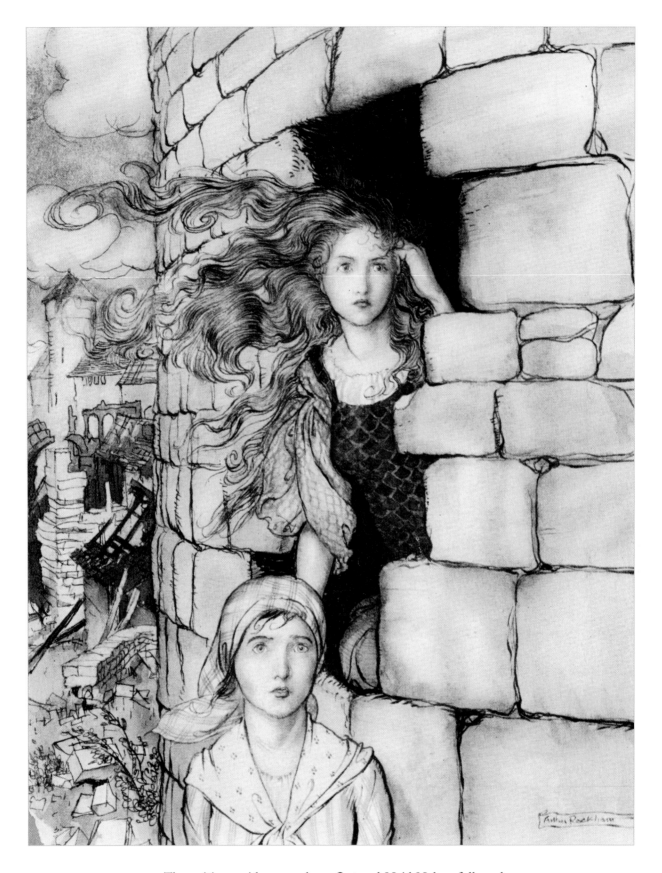

The waiting maid sprang down first and Maid Maleen followed
From "Maid Maleen"

PLATE 7

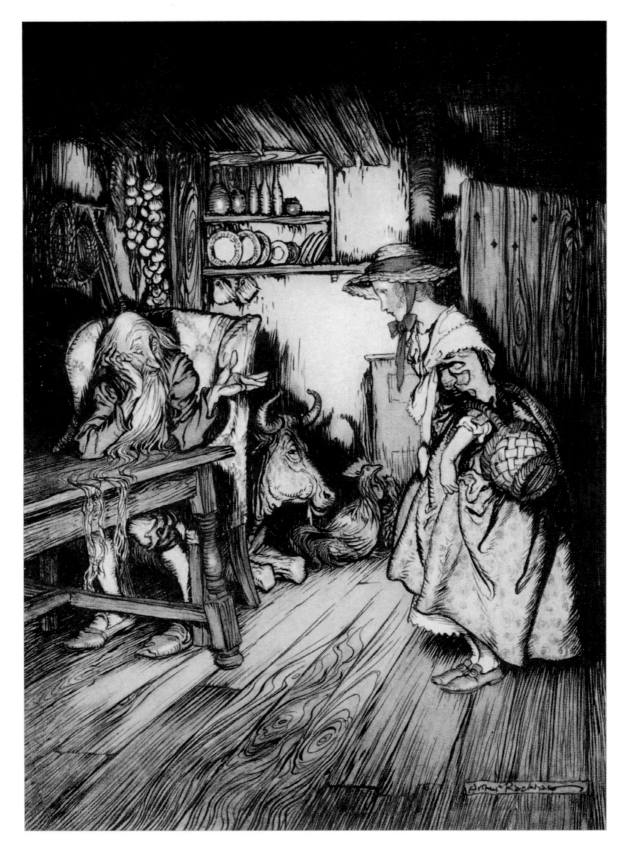

She begged quite prettily to be allowed to spend the night there
From "The Hut in the Forest"

PLATE 8

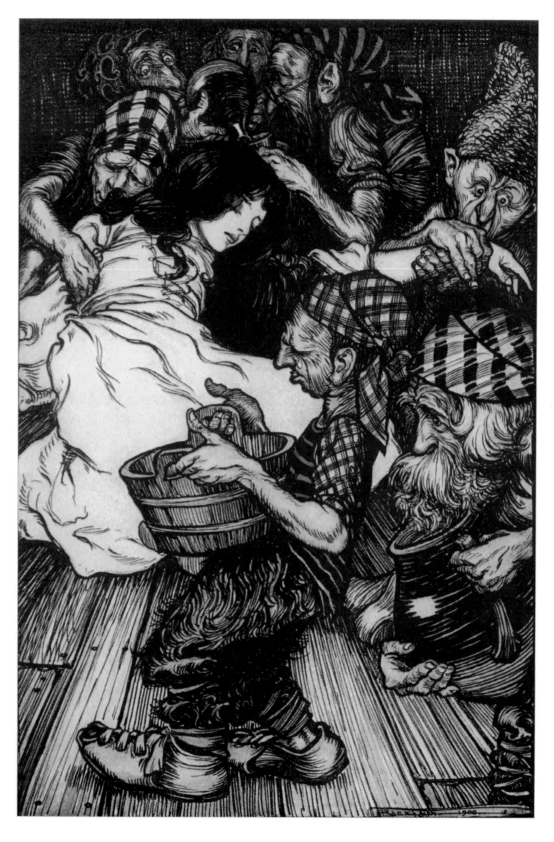

The Dwarfs, when they came in the evening, found Snowdrop lying on the ground
From "Snowdrop"

PLATE 9

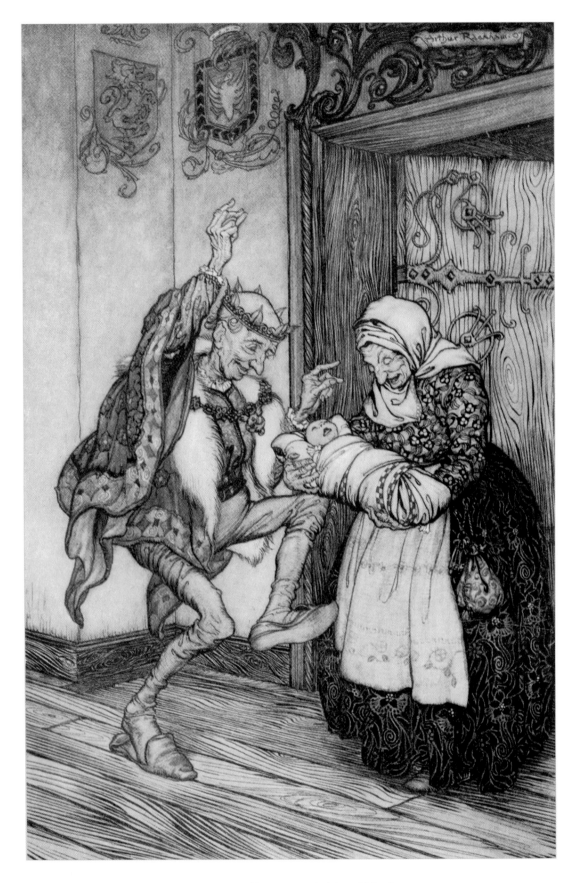

The King could not contain himself for joy
From "Briar Rose"

PLATE 10

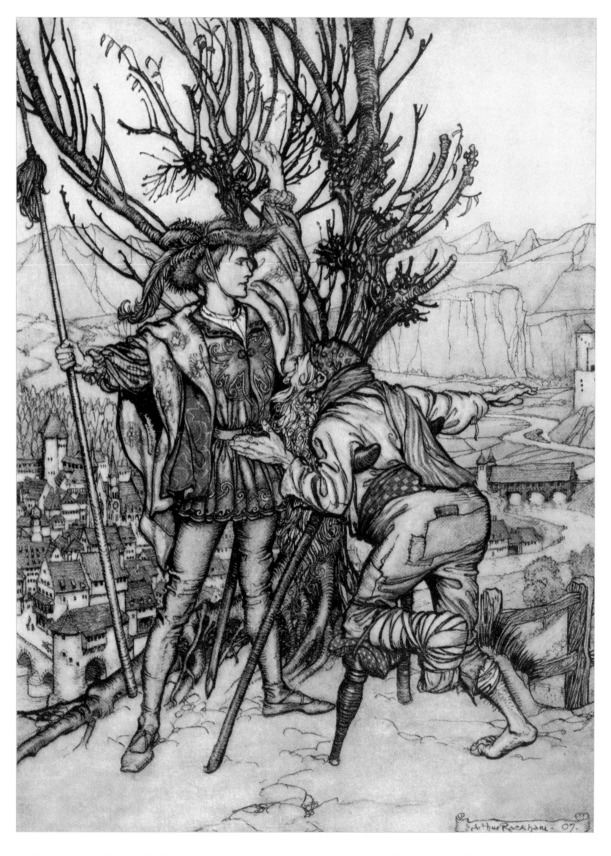

The young Prince said, "I am not afraid; I am determined to go and look upon the lovely Briar Rose"
From "Briar Rose"

PLATE 11

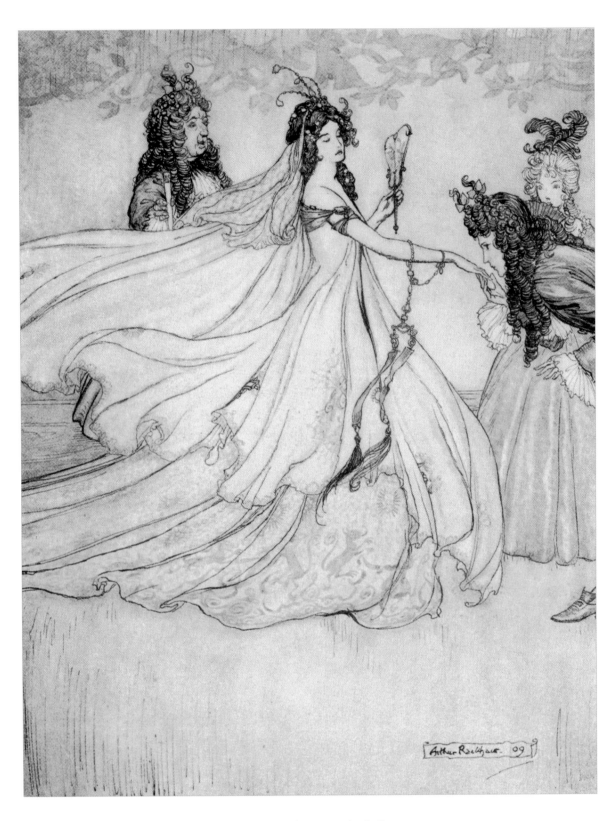

Ashenputtel goes to the ball
From "Ashenputtel"

PLATE 12

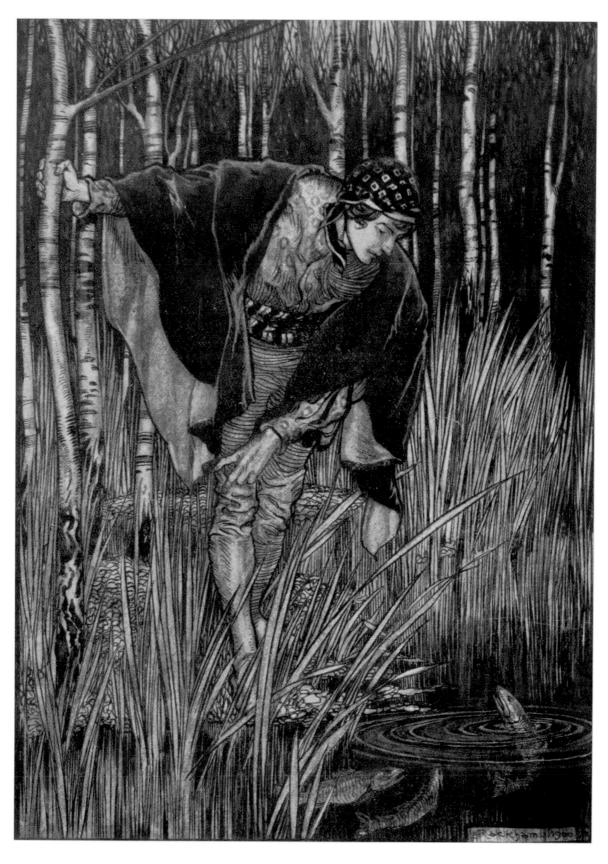

The fishes, in their joy, stretched up their heads above the water, and promised to reward him
From "The White Snake"

PLATE 13

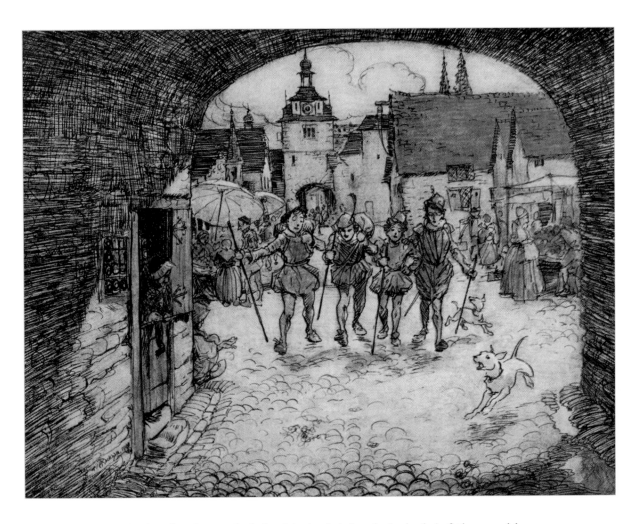

So the four brothers took their sticks in their hands, bade their father good-bye,
and passed out of the town gate
From "The Four Clever Brothers"

PLATE 14

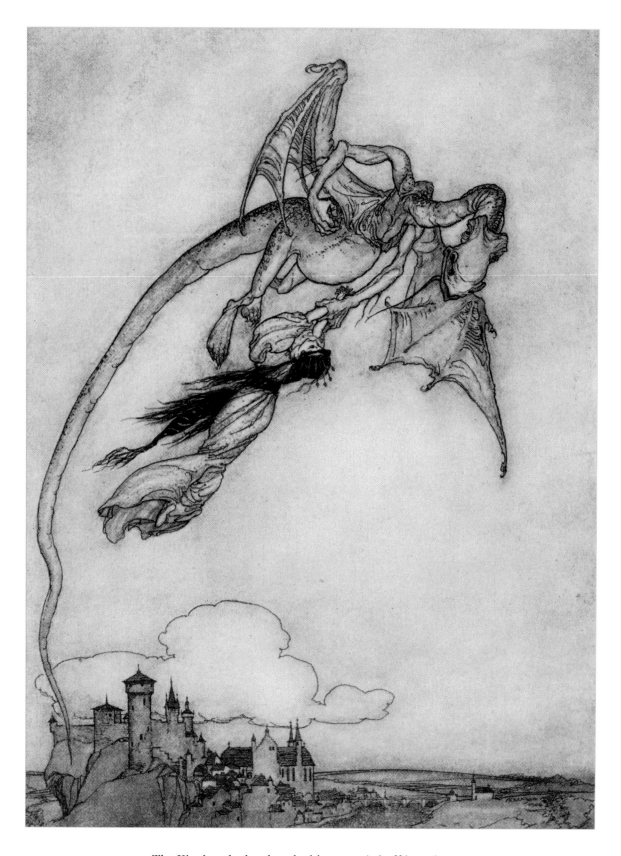

The King's only daughter had been carried off by a dragon
From "The Four Clever Brothers"

PLATE 15

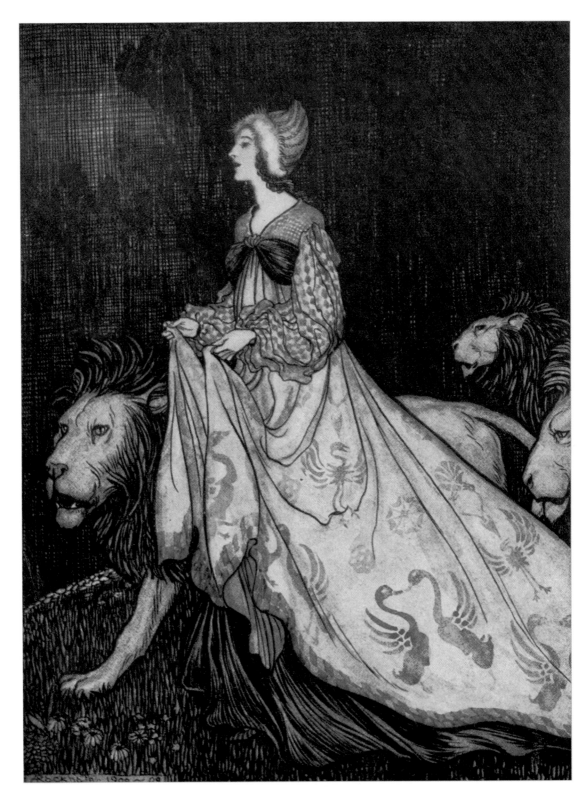

She went away accompanied by the lions
From "The Lady and the Lion"

PLATE 16

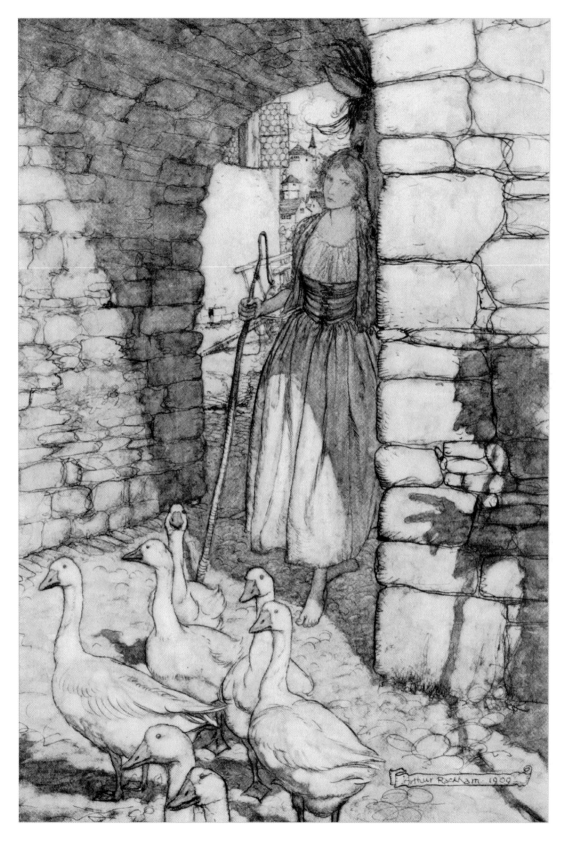

Alas! Dear Falada, there thou hangest
From "The Goosegirl"

PLATE 17

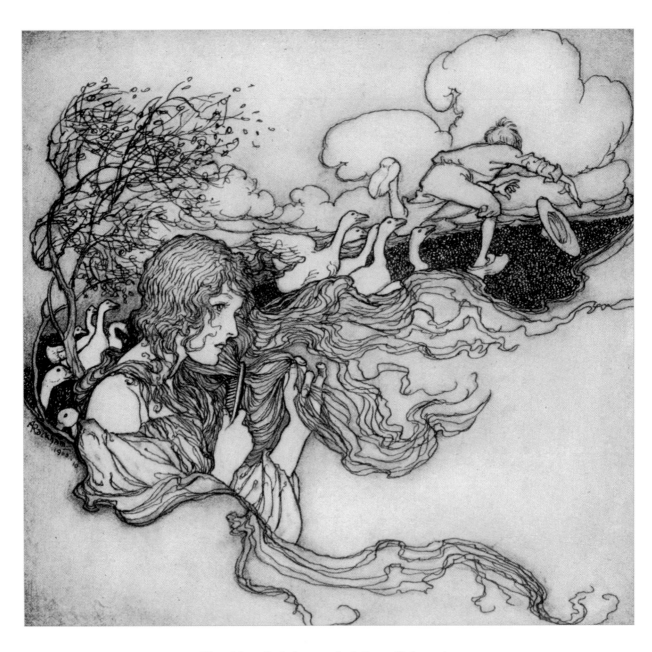

Blow, blow, little breeze, And Conrad's hat seize
From "The Goosegirl"

PLATE 18

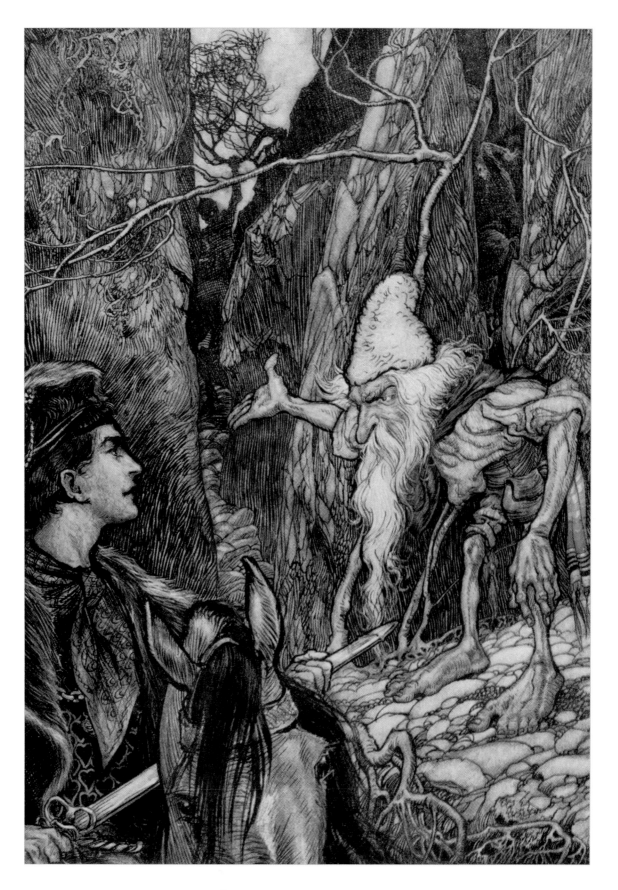

Good Dwarf, can you not tell me where my brothers are?
From "The Water of Life"

PLATE 19

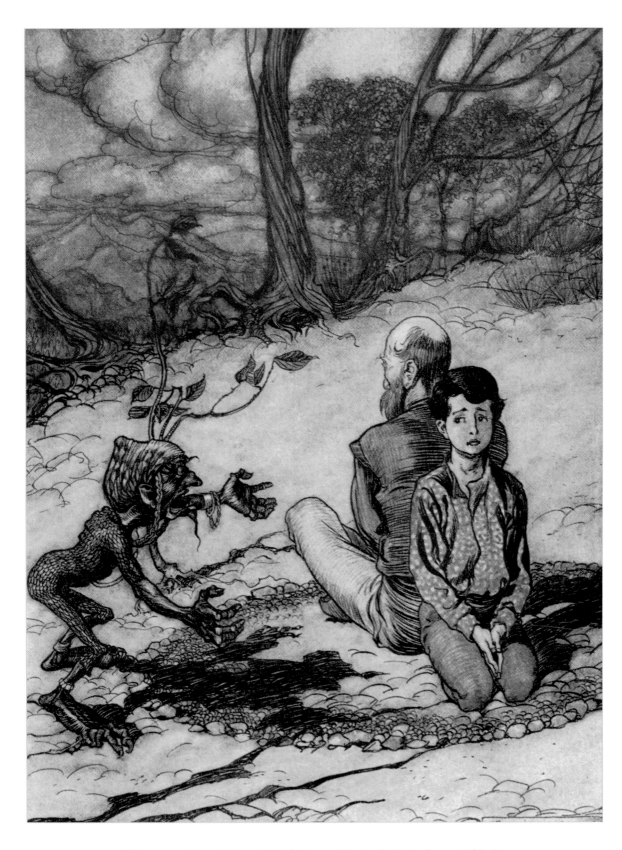

The son made a circle, and his father and he took their places within it,
and the little black Manniken appeared
From "The King of the Golden Mountain"

PLATE 20

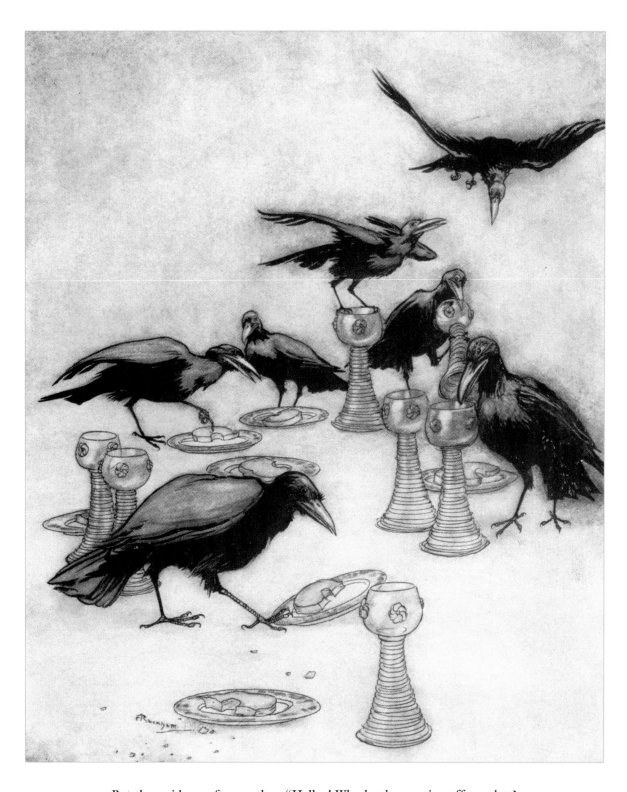

But they said one after another: "Halloa! Who has been eating off my plate?
Who has been drinking out of my cup?"
From "The Seven Ravens"

PLATE 21

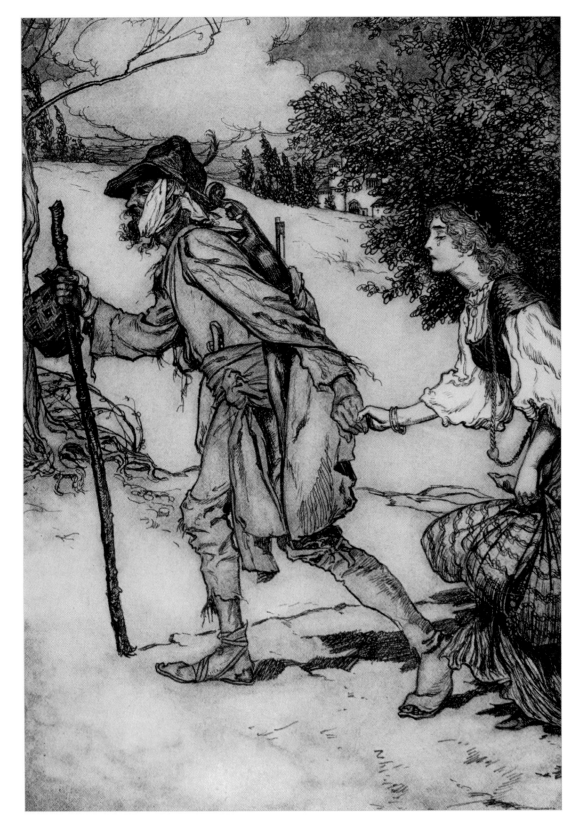

The beggar took her by the hand and led her away
From "King Thrushbeard"

PLATE 22

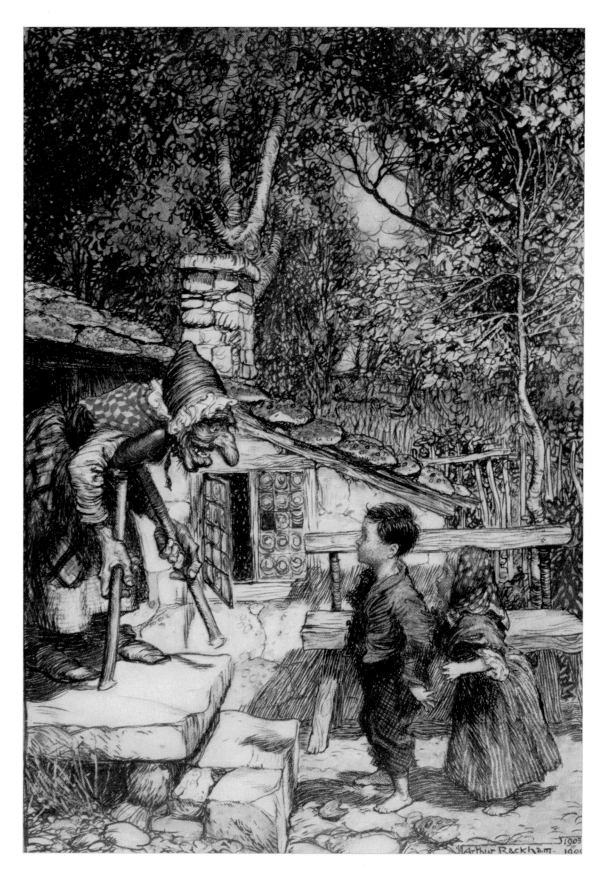

**All at once the door opened and an old, old woman,
supporting herself on a crutch, came hobbling out**
From "Hansel and Grethel"

PLATE 23

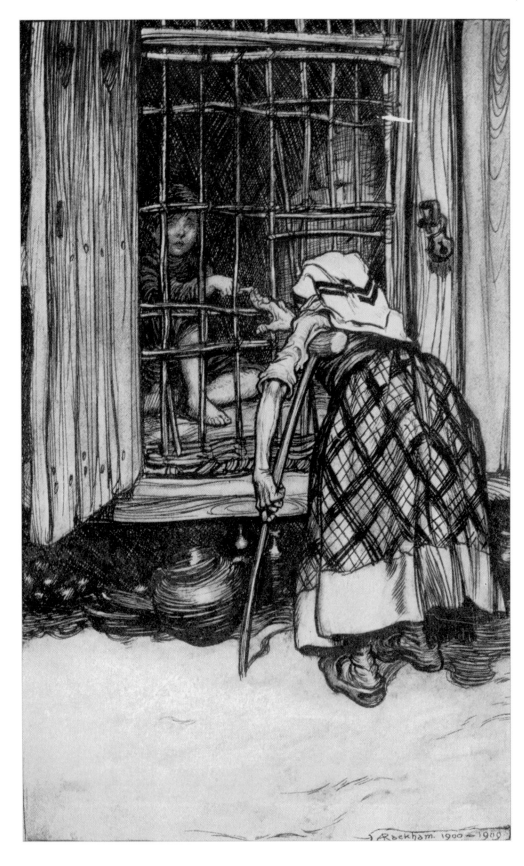

Hansel put out a knuckle-bone, and the old woman, whose eyes were dim, could not see it,
and thought it was his finger, and she was much astonished that he did not get fat
From "Hansel and Grethel"

PLATE 24

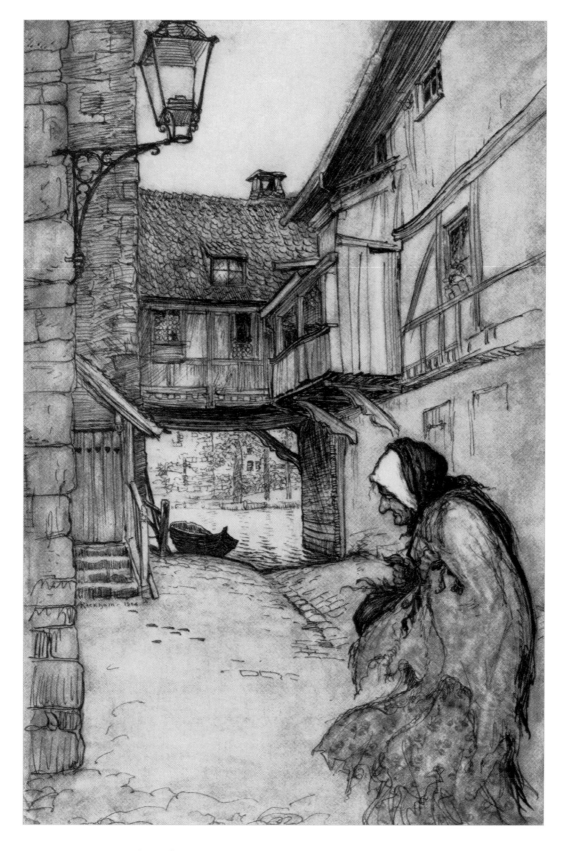

Once there was a poor old woman who lived in a village
From "The Straw, the Coal, and the Bean"

PLATE 25

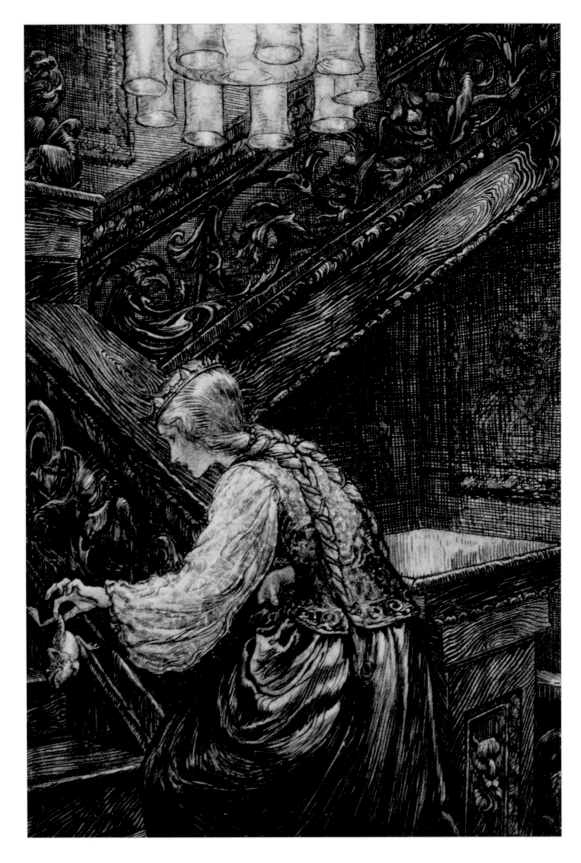

So she seized him with two fingers, and carried him upstairs
From "The Frog Prince"

PLATE 26

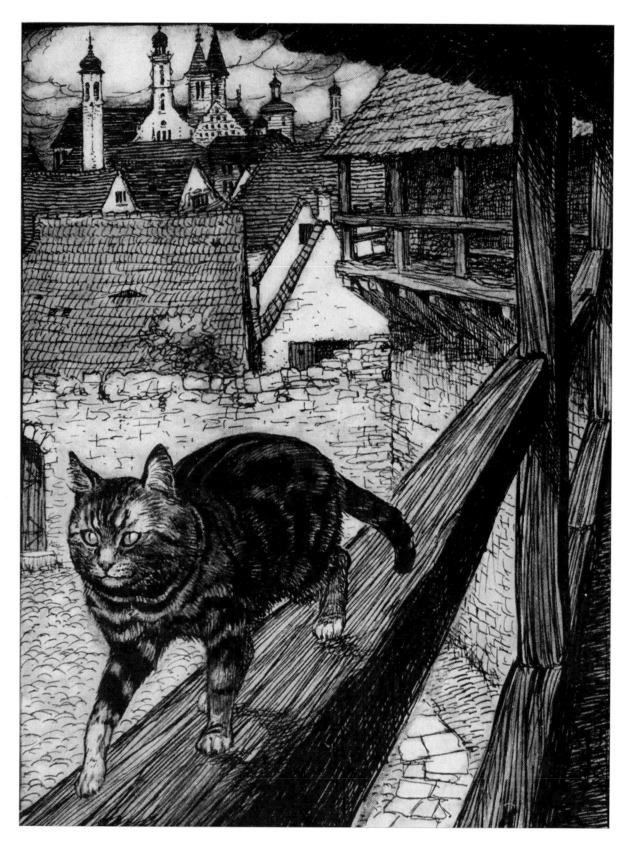

The cat stole away behind the city walls to the church
From "The Cat and Mouse in Partnership"

PLATE 27

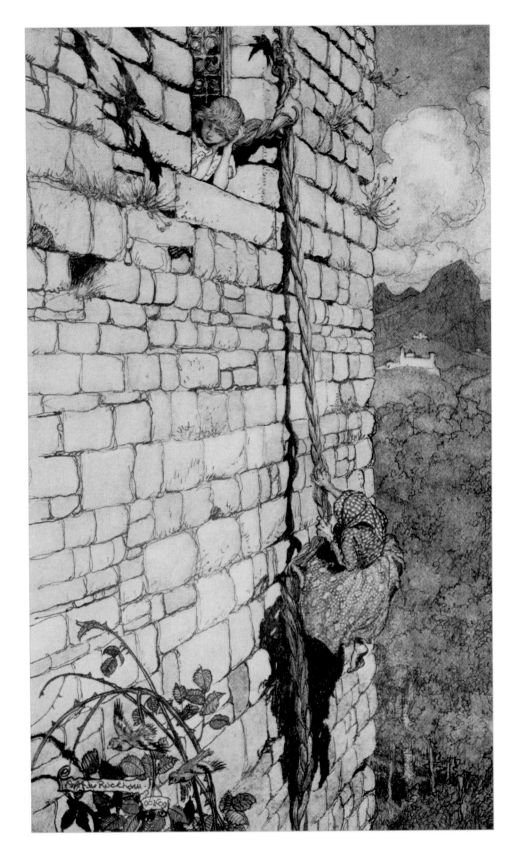

The witch climbed up
From "Rapunzel"

PLATE 28

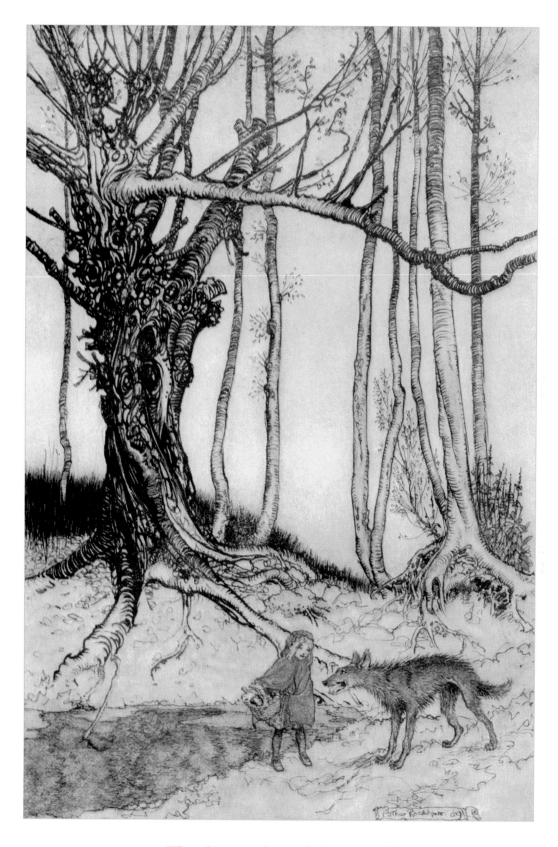

When she got to the wood, she met a wolf
From "Red Riding Hood"

PLATE 29

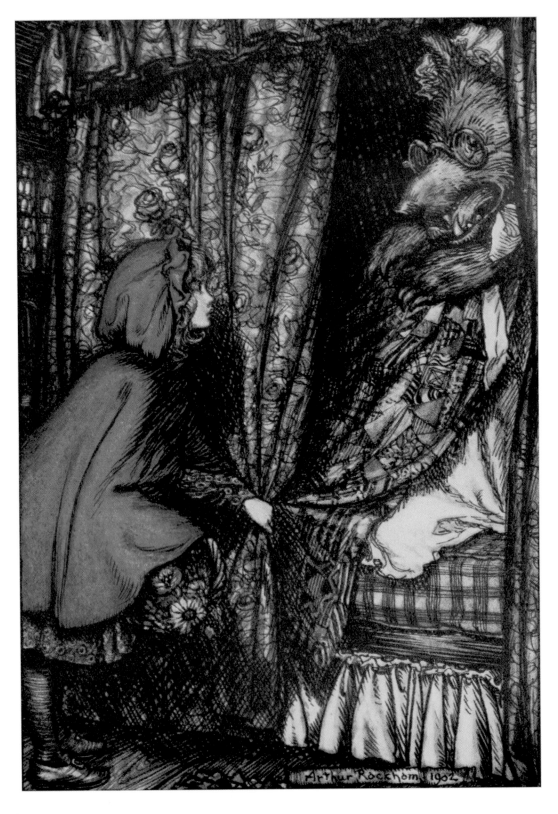

"O Grandmother, what big ears you have got," she said
From "Red Riding Hood"

PLATE 30

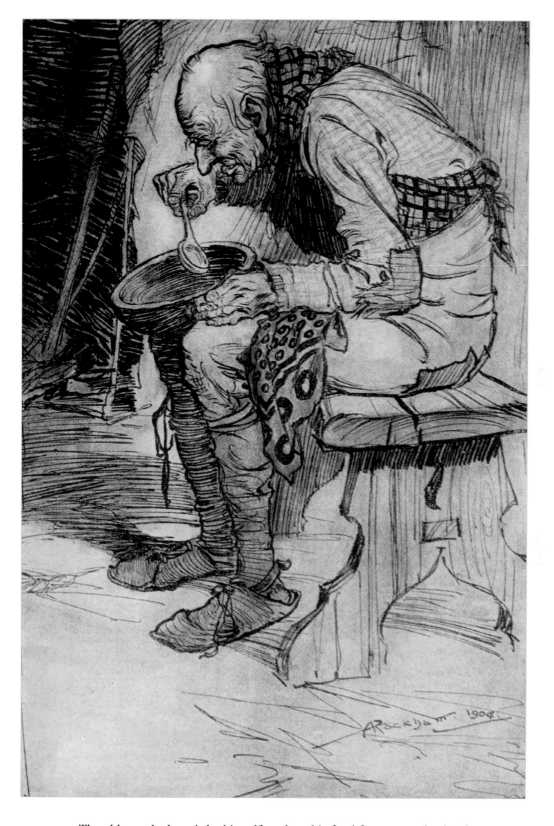

The old man had to sit by himself, and ate his food from a wooden bowl
From "The Old Man and His Grandson"

PLATE 31

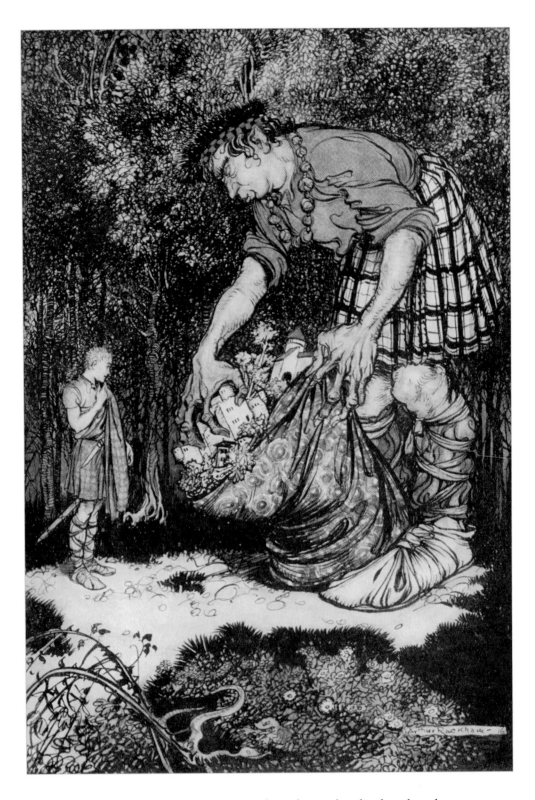

In a twinkling the giant put each garden, and orchard, and castle
in the bundle as they were before
From "The Battle of the Birds"

PLATE 32

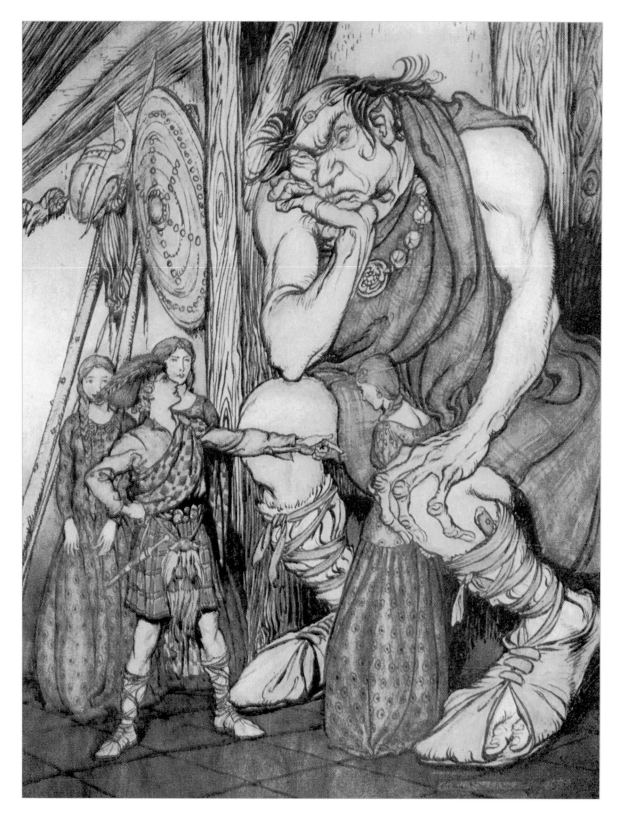

"If thou wilt give me this pretty little one," says the king's son,
"I will take thee at thy word"
From "The Battle of the Birds"

PLATE 33

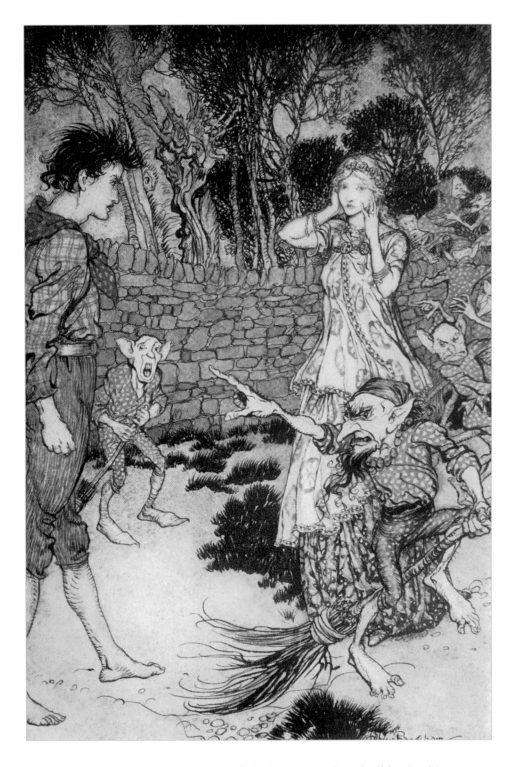

"Now, Guleesh, what good will she be to you when she'll be dumb?
It's time for us to go—but you'll remember us, Guleesh!"
From "Guleesh"

PLATE 34

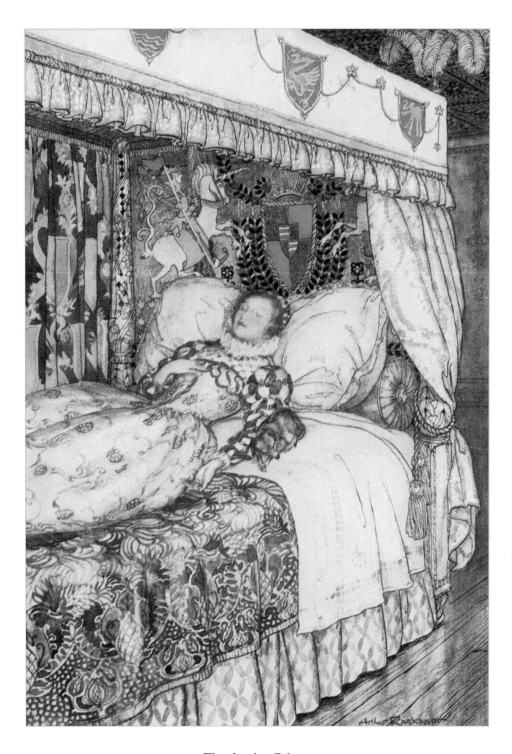

The sleeping Princess
From "The Sleeping Beauty"

PLATE 35

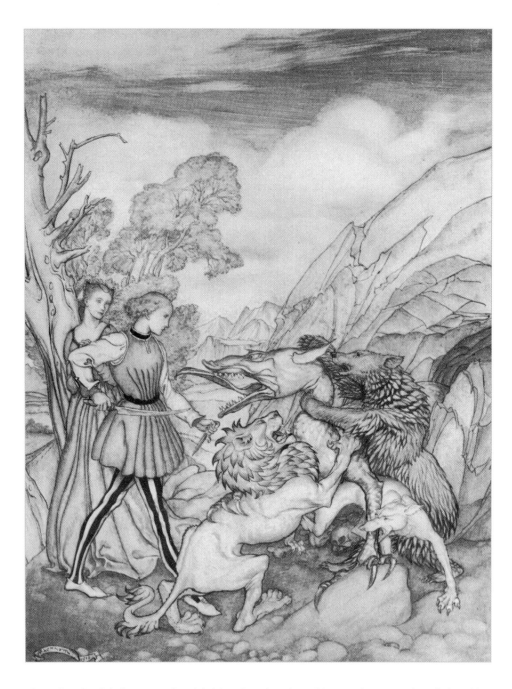

So valiantly did they grapple with him that they bore him to the ground and slew him
From "Cesarino and the Dragon"

PLATE 36

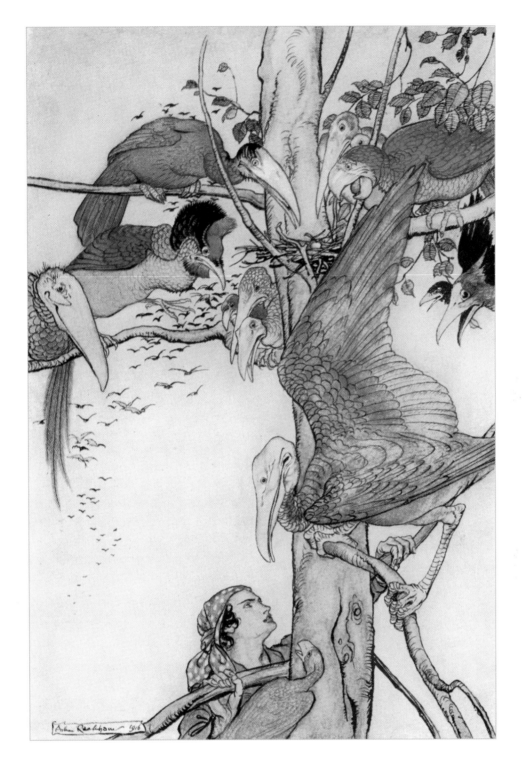

The birds showed the young man the white dove's nest
From "What Came of Picking Flowers"

PLATE 37

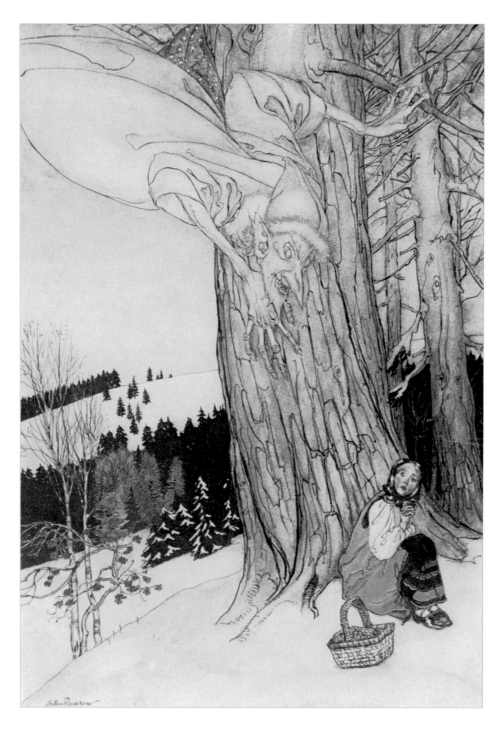

"Art thou warm, maiden? Art thou warm, pretty one? Art thou warm, my darling?"
From "Frost"

PLATE 38

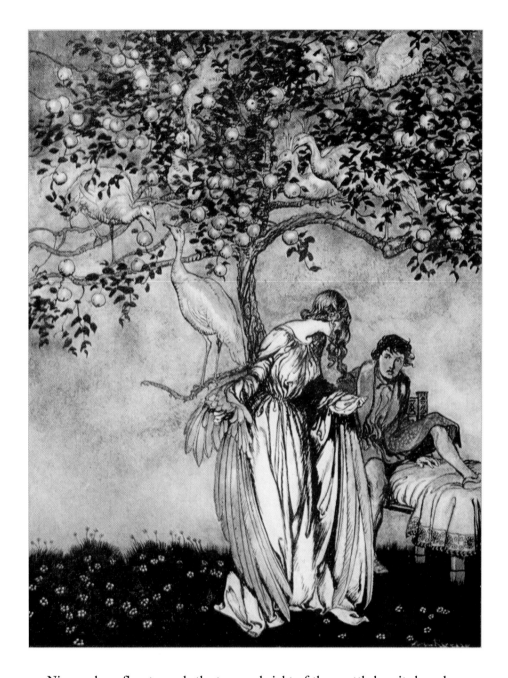

Nine peahens flew towards the tree, and eight of them settled on its branches,
but the ninth alighted near him and turned instantly into a beautiful girl
From "The Golden Apple-Tree and the Nine Peahens"

PLATE 39

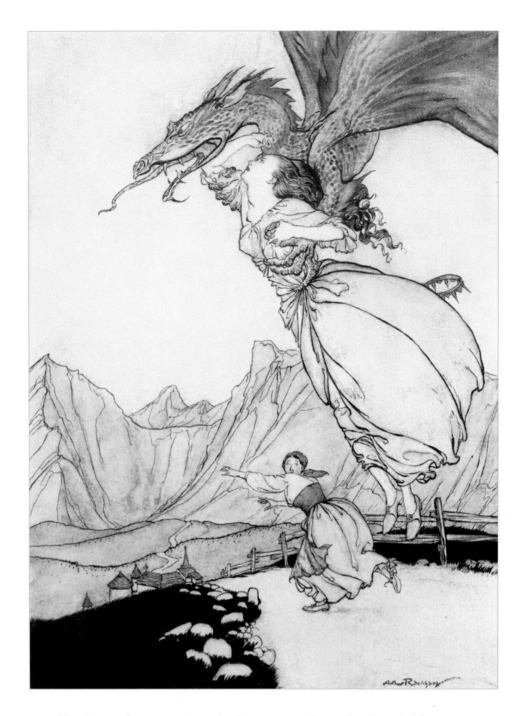

The dragon flew out and caught the queen on the road and carried her away
From "The Golden Apple-Tree and the Nine Peahens"

PLATE 40

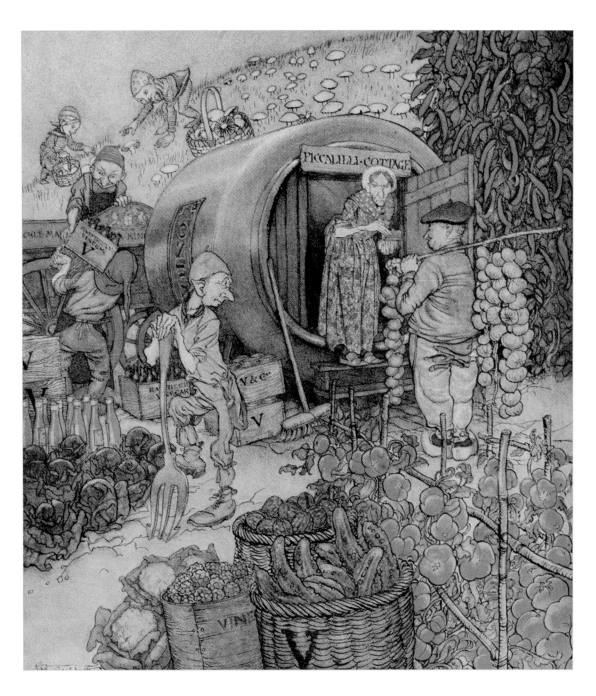

Mr. and Mrs. Vinegar at home
From "Mr. and Mrs. Vinegar"

PLATE 41

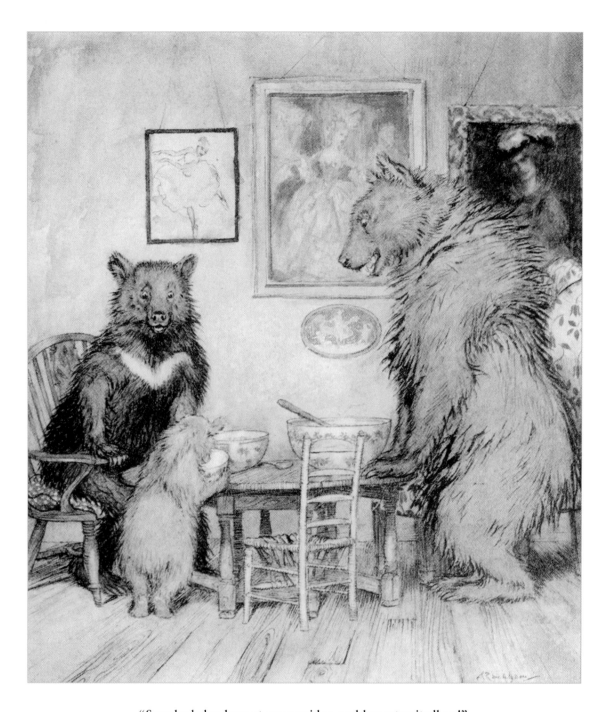

"Somebody has been at my porridge, and has eaten it all up!"
From "The Story of the Three Bears"

PLATE 42

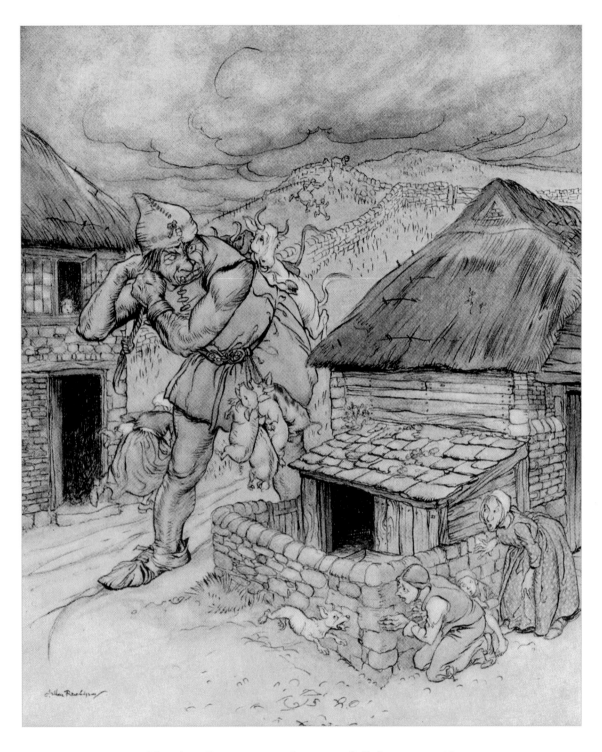

The giant Cormoran was the terror of all the country-side
From "Jack the Giant-Killer"

PLATE 43

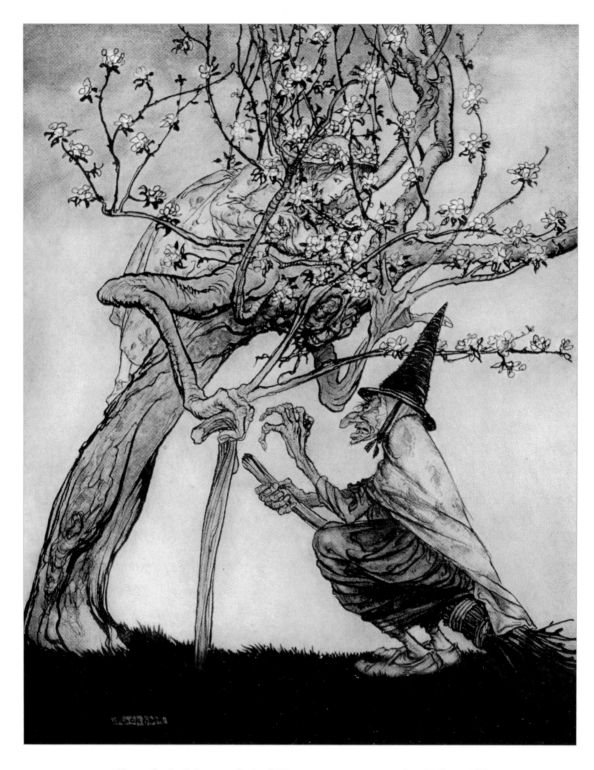

"Tree of mine! O tree of mine! Have you seen my naughty little maid?"
From "The Two Sisters"

PLATE 44

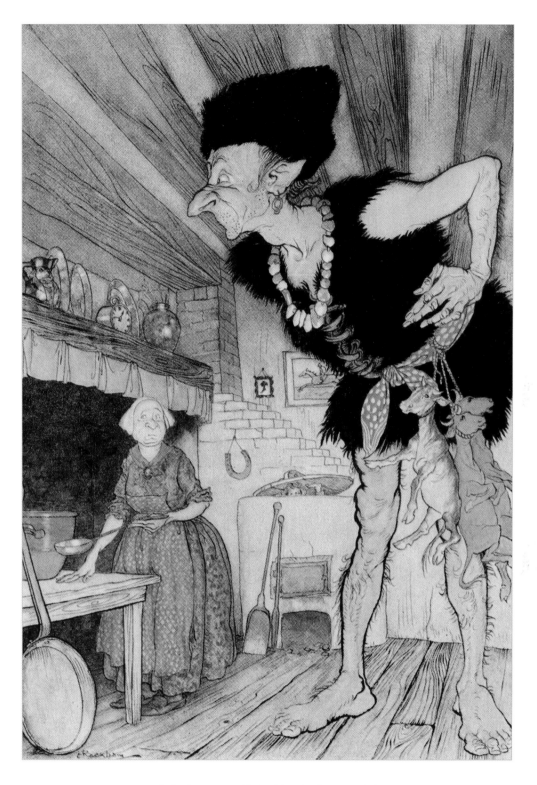

"Fee-fi-fo-fum, I smell the blood of an Englishman"
From "Jack and the Beanstalk"

PLATE 45

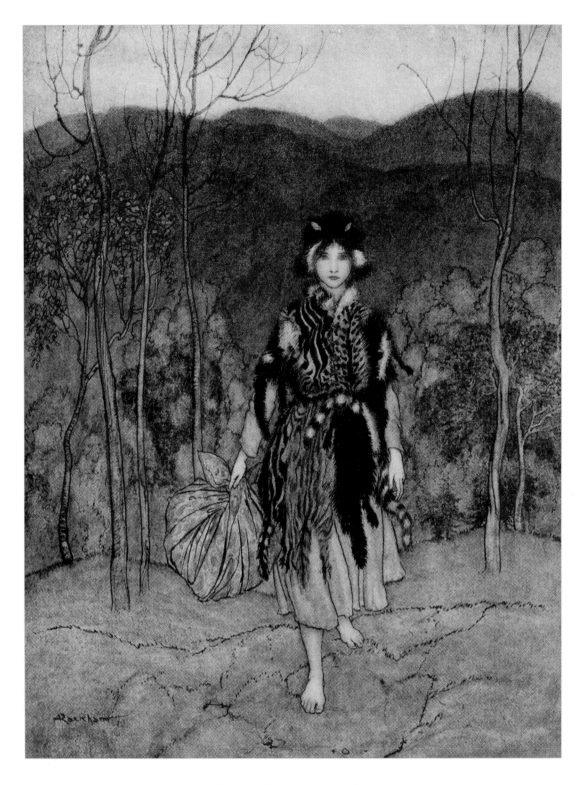

She went along, and went along, and went along
From "Catskin"

PLATE 46

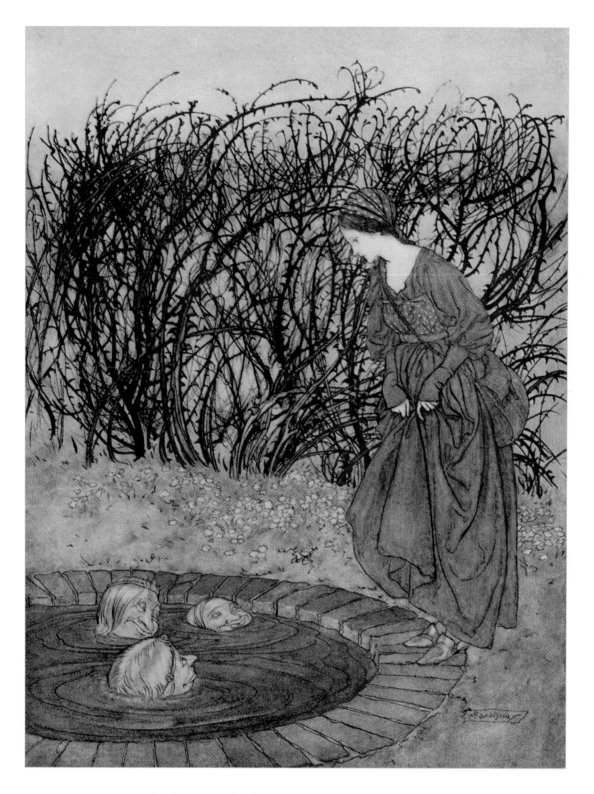

They thanked her and said good-bye, and she went on her journey
From "The Three Heads of the Well"

PLATE 47

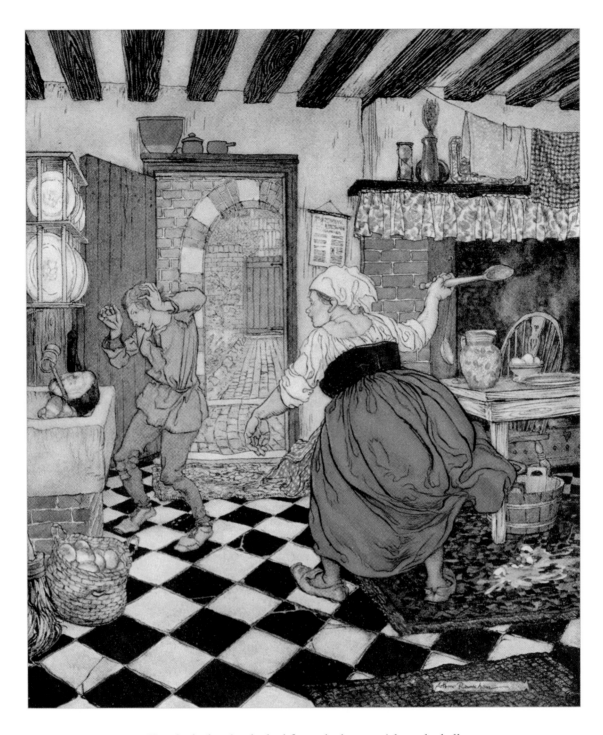

Many's the beating he had from the broomstick or the ladle
From "Dick Whittington and his Cat"

PLATE 48

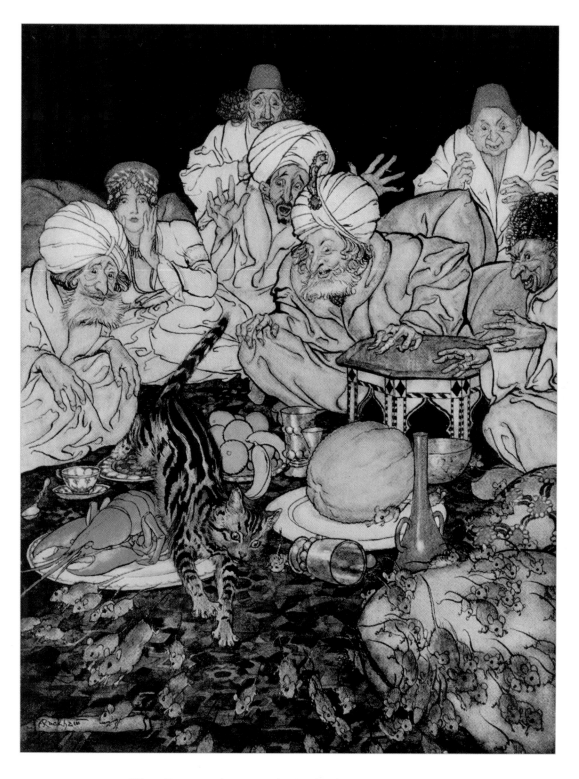

When Puss saw the rats and mice she didn't wait to be told
From "Dick Whittington and his Cat"

PLATE 49

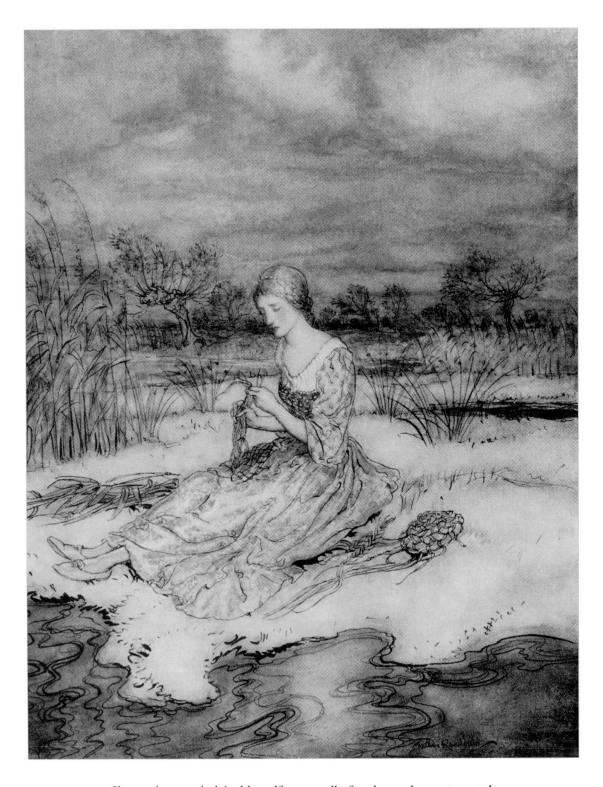

She sat down and plaited herself an overall of rushes and a cap to match
From "Caporushes"

PLATE 50

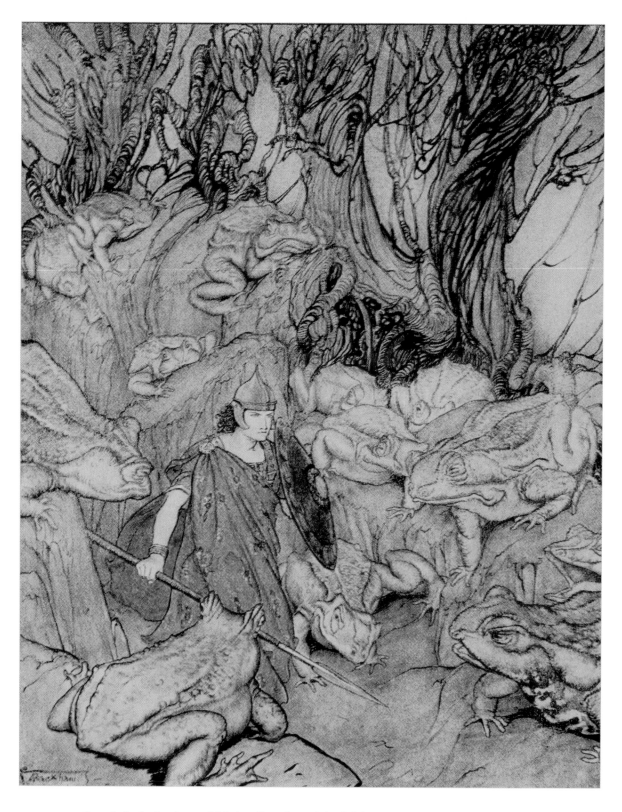

In a forked glen into which he slipped at night-fall he was surrounded by giant toads
From "Becuma of the White Skin"

PLATE 51

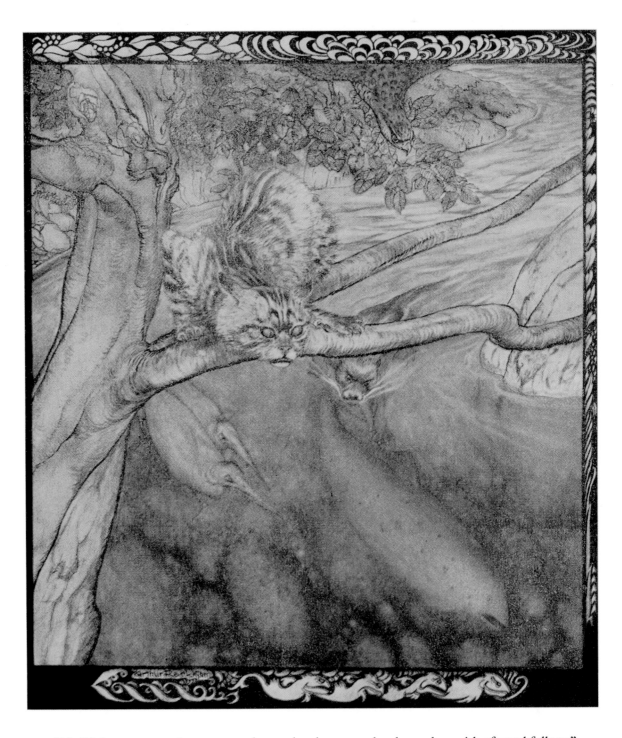

"My life became a ceaseless scurry and wound and escape, a burden and anguish of watchfullness"
From "The Story of Tuan Mac Cairill"

PLATE 52

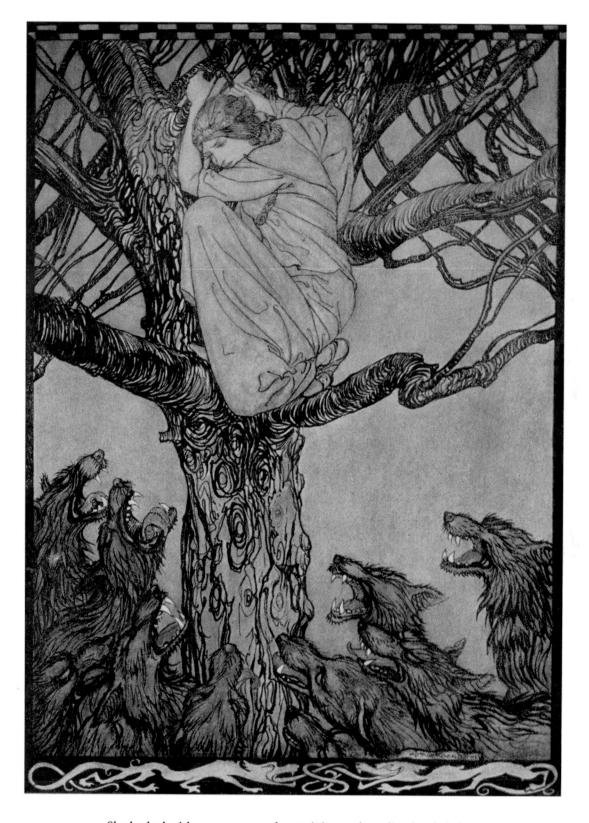

She looked with angry woe at the straining and snarling horde below
From "The Wooing of Becfola"

PLATE 53

THE END